The American Family

*A Pictorial Celebration
By the Winners of the Parade-Kodak
National Photo Contest
Introduction by
Walter Anderson*

The American Family

CONTINUUM • NEW YORK

"You Should Have Seen Us!" What the Swanson boys—David, 10, Tom, 7, and Mike, 6 (l-r)— are sure to talk about back home. Photo taken in Fort Lauderdale, Fla., by their father, Lee Swanson of North Riverside, Ill.

1995

The Continuum Publishing Company
370 Lexington Avenue
New York, NY 10017

Copyright © 1995 by Parade Publications, Inc.

Design by Ira Yoffe

All rights reserved.
No part of this book may be reproduced,
stored in a retrieval system,
or transmitted in any form or by any means,
electronic, mechanical, photocopying,
recording or otherwise,
without the written permission of
The Continuum Publishing Company.

Printed in Hong Kong

Library of Congress Cataloging-in-Publication Data
The American Family : a pictorial celebration of America /
by the winners of the Parade-Kodak Photography Contest ;
introduction by Walter Anderson ;
with reflections by Eddie Adams ... [et al.].

p. cm.
ISBN 0-8264-0826-5(hardcover)
1. Photography of families.
2. Family—United States—Pictorial works.
I. Anderson, Walter, 1944- .
II. Eastman Kodak Company.
III. Parade (New York, N.Y.)
TR681.F28A43 1995
779'.26'0973—dc20 95-12038 CIP

Mug Shots: Meghan Quigley, 8, teams up with her golden retriever, Ally, in her grandma's backyard. Photo by Matthew Mellett of Caldwell, N.J.

INTRODUCTION

The family, everyone seems to agree, is the centerpiece of American life. Certainly it's the centerpiece of American photography. It's probably safe to say that people take more pictures of their children than of any other subject. Most of them start at birth, and from then on life literally flashes by, from birthdays, to graduations, to weddings, to the arrival of grandchildren....And somewhere along the way, it's the children who become the photographers and the parents the subjects, and the cycle is endlessly renewed.

What you will see in the pages that follow is a family album of America itself. These are the winning photos in the eighth annual Parade-Kodak National Photo Contest. As the editor of Parade Magazine, which every Sunday reaches more than 80 million readers in almost 38 million homes in 50 states, I'm well acquainted with the ability, creativity and resourcefulness of Americans in whatever occupation or pastime they pursue. Nevertheless, I admit to be surprised by the originality, imaginativeness and sheer beauty of these photos, nearly all taken by non-professionals. And I'm glad to say that much the same reaction was reported by our distinguished panel of judges — Eddie Adams, Pulitzer Prize-winning photographer and special correspondent for Parade; Dr. Joyce Brothers, psychologist and writer; Marian Wright Edelman, president of the Children's Defense Fund; Michael Eisner, chairman and CEO of the Walt Disney Co. and Carol H. Rasco, domestic affairs adviser to President Clinton. You'll find the judges' comments elsewhere in this book.

This warm-hearted collection of photos gives new meaning to the term "extended family." For family, to Americans, means more than just the folks who live together in the same house. In many instances, it also encompasses friends, neighbors and distant relatives who share in the joys and sorrows that make up life. It even includes those who are no longer with us, as depicted in one photo I found particularly moving, a daughter kissing the gravestone of her father, a veteran of World Wars I and II.

Not surprisingly, children predominate. But you won't find those posed, studio-type children's portraits that used to adorn many a mantelpiece. These are America's children as they are, playing, studying, celebrating, doing household chores, unashamedly displaying their affection for parents, grandparents, friends and neighbors. They're America's children as we really know them, yet depicted with an artistry that captures all their freshness and vitality. There's nothing more beautiful than a happy child, and you'll find many of them in this book.

So, welcome to a picture gallery that shows the kinship and friendship that unites us despite our diversity, and that reaffirms family values in an era that sorely needs them.

WALTER ANDERSON

Like Family: Micah Burris (l), 6, and Sterling Davis, 5, after sharing a really close look at some fountains in Kansas City, Mo. Photo by their neighbor, Randy Farr of Kansas City.

8

House Party: Fifty members of the Riemer family went to Westport Harbor, Mass., for a summertime reunion. Here, some of the gang gather at the Howland House, a landmark rented for the occasion. Photo by Bert Myer of Hampstead, N.H.

10

*Take a Deep Breath: On Dad's birthday, everyone can help with the candles. Leigh Gunther
of Coral Springs, Fla., snapped the photo of her husband, Robert, and sons (l-r) Ted, 3, Max, 5, and Fritz, 1.*

11

"*We are family!*"
—Sister Sledge

"*All happy families are alike....*"
—Leo Tolstoy

"*Don't join too many gangs, join few if any, join the United States and join the family.*"
—Robert Frost

"*Birds in their little nests agree;
And 'tis a shameful sight,
When children of one family
Fall out, and chide, and fight.*"
—Isaac Watts

After a Bath: Debra Anderson, 34, with her nephew and godson, Peter Burg, 7 months. Photo by Kathleen Graff of Milwaukee, Wis.

Remember That Day? Members of the Keating, Guglielmo, Burke, Wilson and McBean families set out for the softball field on a summer evening in 1980 on Isle Au Haut, Maine. Photo by Jim Keating of Kalamazoo, Mich.

Leave It to Brother: Chad Gregory, 14, is eager to share the glories of fall with his sister Lauren, 6. Photo by their grandmother, Bonnie B. Werntz, at her home in South Bend, Ind.

The Family That Plays Together: Photo by Roy Pope of Burbank, Ill.

Family With Sole: It may be arch, but this is the Cambre family portrait of Branson, 2, Christopher, 4, Chase, 7, Brooke, 10, and parents Sandra and Rick. Pho-toe by John Daigre of New Iberia, La.

A Birthday Ride in Barcelona: Bernerd Garsen and his wife, Catherine, celebrate the sixth birthday of their daughter, Alicia, on an amusement park ride in Barcelona, Spain. Photo by Bradford Noble of San Francisco, Calif.

Steppin' Out: Ryan Donovan, 1, with his grandparents, Ronald and Barbara Mosca, in Whiting, Ind. Photo by his aunt, Deborah Mosca of San Francisco, Calif.

Heart Strings: Julie La Riva with her son, Damien, who played a violin solo at the fifth-grade graduation at Buena Vista Elementary School in San Francisco, Calif. Photo by Bill Hackwell of San Francisco.

She'll Lend a Hand—and a Leg: Theresa, 10, Mark, 7, and Patrick Barron (r), 6, catch up with their mother, Susie, at the end of the school day. Photo by Richard C. Finke of St. Louis, Mo.

Safe and Sound: Sophia Hurst, 6, and her great-grandmother, Dory Stuart (whose age is a family secret), relax on the porch swing at the Stuart home in Folsom, Calif. Photo by Sophia's mother, Julie Hurst of Kilauea, Hawaii.

"I Look Up to You Two": Rebecca Butler, 6 months, on her front porch in West Orange, N.J., with her grandfather, Robert Theise (l), 73, and great-uncle, Jerry Theise, 69. Photo by Rebecca's mother, Roberta Butler of West Orange.

High Tea: Laura Gervais, 3, entertains her "family" of antique dolls and teddy bears. Photo by Linda Cordone of Milford, Mich.

31

"Sonny" Days: Robert Wiseman of Sharpsburg, Ga., and son, Kyle Robert, 1, wade through a field in Kansas, "the Sunflower State." Photo by Kyle's mother, Pamela Oaten.

"We Are Family": Wendy and John Garvey and their children—Emerald, 13, Coral, 10, and Teak, 2—outside their summer home on Martha's Vineyard. Photo by Wendy's mother, Judy Alden of Westborough, Mass.

*Family Scrapbook: Three generations of the Wimberg family assemble at Lake Tahoe in California.
Photo by Randy "Breathless" Wimberg (bottom left) of Van Nuys, Calif.*

37

Meet at the Moore's House: Three families and a few friends got together to feast on a Maryland favorite—crabs. Photo by Debra Lynn Rudd of Street, MD.

Special Times: Fleming Williams, 42, takes his sons—Brett (l), 10, and Blake, 12—out on the pond on the first day of spring in Barney, Ga. Photo by his wife, Helen Williams of Barney.

Finer Points: Lewis "Papa" Leslie shows his great-grandson, Samuel George, 4, how to land the big one. "Papa taught all of his grandchildren how to fish—it's his passion," says the photographer, Leslie B. George of Flint, Tex.

A March Evening: Harold Connor and his three children — Shane, 7, Sara, 9, and Daniel, 6 (l-r) — on Suttle Lake in Oregon. Photo by Terri Connor of Bend, Ore.

A Sisterhood: Millie Nelson (l), 79, and Helen Byrnes, 91, are neighbors in the same building. Millie has taken care of her blind friend for years. Photo by Donna Isaac of Somerville, Mass.

Mother and Daughter: Michelle, 47, and Erika Hanke, 18, of Copley, Ohio, share mixed emotions as Erika leaves for college. Photo by Pat Bishop of Akron, Ohio.

"Hold On!" Paul Arthur Rodriguez, 4, about to graduate from preschool, doesn't want his great-grandfather, Arthur John Muzzy, 87, of Inverness, Fla., to miss the ceremony. Photo by Rose Marie Boone of Inverness.

"Keep Steering, Grandpa!" Hunter Stipp, 14 months, isn't giving up, while his grandfather, Frank Cain, concentrates on his steering. Photo by Hunter's grandmother, A. Elaine Cain of Robstown, Tex.

48

Nelbert Little Mustache — a Blackfoot Indian of the North Peigan Tribe — holds his month-old granddaughter, Tawnya Lacey Plain Eagle, at a powwow sponsored by the Plains Indian Museum in Cody, Wyo. Photo by Chris Gimmeson of Powell, Wyo.

*Sunday Best: A family on its way to church in Washington, D.C.
Photo by Ken Benjamin of Los Gatos, Calif.*

Day of Rejoicing: Benny Rubin, 13, celebrates his bar mitzvah with his parents, Steve and Sue Rubin, and his four brothers, Tom (l-r), 26, Alan, 24, and twins Gary and Richard, both 11. Photo by James S. Clifford of Somerville, N.J.

*The Birthday Party: Patrick Rouane (l) celebrates his first birthday, in Columbus, Mont. Activities included hugging (**mom**, Rayetta, and sister, Stephanie) and tricycling (brother, Jeremiah, pushes cousin, Tessa). Photo by Stacey Rouane of Columbus.*

"Give Us This Day..." The Hackworth family of Lithonia, Ga., breaks bread. Clockwise from top: Mark, Michelle, Adrienne, Ashley and Mark Jr. Photo by Richard Williams of Decatur, Ga.

Sisters: Six Dominican nuns from the Corpus Christi Monastery enjoy an evening in their monastery garden. These cloistered nuns have a rule of silence, so conversation is a big part of their recreation. Photo by Sister Mary of the Holy Spirit of Menlo Park, Calif.

Shelter From the Storm: Nicholas Fusillo, 1, with his father, Douglas, in Delray Beach, Fla. Photo by Nicholas' grandmother, Mary Fusillo of Canastota, N.Y.

Sweet Dreams: Three-month-old Daniel Anthony Gonzales takes a long look at his aunt, Aileen Maria Rolón, 15, before he drifts off to sleep. Photo by Nick Alvarado of Fort Worth, Tex.

Dad's My Bed: Alina Bonacquista, 10 months, dozes with her father, Mark, by a creek in Arizona. Photo by Alina's mother, Virginia Bonacquista of San Pedro, Calif.

Tummy Play: Marshall Siler and his daughter, Jessica, 6 months. Photo by Jessica's mother, Lynne Siler of Atlanta, Ga.

Let's Get Movin': John Hannahs, 3, at the wheel of a friend's truck—and furry pal, Kip, are ready to go to work. Photo by John's mother, Kathryn Hannahs of Parkman, Wyo.

"Hangin' On": J. Taylor Lewis, 14 months, clings to her father, John R. Lewis, as they go for a spin in the West Virginia countryside. Photo by Taylor's mother, Suzanne Park-Lewis of Bridgeport, W.Va.

His First Lesson: Ed Tuzinski, a truck farmer, and his grandson, Matthew Chapman, 4. Photo by Susan Bonzi of Syracuse, N.Y.

*Labor Day: After packing the car to head back home, David and Susan Doherty and their children —
Joseph, 8, and Lauren, 11 — collapsed on the picnic table. Photo by Jean Thompson of Chicago, Ill.*

A New Family: Brent Casey, 19, of Stone Mountain, Ga., and his newborn son, Hadyn. The proud mother is Sherri McCullough, 17, of Demorest, Ga., who had undergone an emergency cesarean section the day before. Photo by Colleen M. Casey of Atlanta, Ga.

"Made It!" Shirley L. Frost, 33, of Marstons Mills, Mass., celebrates receiving her Associate in Science Nursing degree from Cape Cod Community College with husband, Randall, 40, and children, Nathan, 8, and Melissa, 6. Photo by Lawrence W. Frost of Murrysville, Pa.

Gentle Waking: Britt Kindle and her nephew, Andrew, 2. Photo by Britt's fiancé, Craig Paxton of Saline, Mich.

"God setteth the solitary in families."
— Psalm 68

"You can never lose your family."
— The Godfather, Part II

"You-all means a race or section,
Family, party, tribe, or clan;
You-all means the whole connection
Of the individual man."
— Anonymous

"The little world of childhood with its familiar surroundings is a model of the greater world. The more intensively the family has stamped its character upon the child, the more it will tend to feel and see its earlier miniature world again in the bigger world of adult life."
— Carl Gustav Jung

Home for the Holidays: Cmdr. Wayne D. Gusman of the U.S. Coast Guard and his sons — Bryan (l), 11, and Wayne, 13 — outside his cousin's home in Gretna, La., on Christmas Day. Photo by Wayne's cousin and longtime friend, Stephen Chachere of Beacon, N.Y.

Three Generations: Chris Bordelon, 49, holds her granddaughter, Mercedes, as the new mother — Melanie Passman, 20 — watches. Photo by Gregory J. Passman of Shreveport, La.

Who Needs Dolls? Audrey Stilson, 5, helps care for her little sister, Mary, 3 months.
Photo by Anne Smoot of Provo, Utah.

Aaron Hunter Litman, 10 days, and his great-great-aunt, Mildred, relax during a Fourth of July picnic. Photo by Aaron's aunt, Deanne Kacmar of Smithfield, Pa.

Safe and Contented: Nick Wilsey of Canoga Park, Calif., is shown safe in the arms of his late great-grandfather, Harold McCubrey. Harold's daughter, Joanne McCubrey of Placerville, Calif., took the photo.

Shared Secrets: Annie Lee Manning, 72, listens to her great-granddaughter, Jennifer Curley, 1. Photo by Lee Manning of Black Forest, Colo.

Quiet Time: Jennie Calvey and her grandson, Ryan Calvey, 3, watch the other kids play baseball. Photo by Maria Moricca-Calvey of Lake Ronkonkoma, N.Y.

As Only Sisters Can: Mary DeGenova, 54, of Stoneham, Mass., and Phyllis Brothers, 59, of Tewksbury, Mass., whoop it up in the kitchen. "They were best friends," says Mary's daughter, Ellen DeGenova of Cambridge, Mass., who took the photo.

Sister Act: Chelsea Ropes, 7, gets wild and crazy with her younger sister, Katie, 5. Photo by Mark Ashman of Orlando, Fla.

Just Like Old Times: Kitami Blakey, 4, and her brother, Isaiah, 9, dressed in turn-of-the- century costumes to celebrate their church's centennial in Santa Cruz, Calif. Photo by their mother, Sarah Blade of Santa Cruz.

"I'll Show You the Way": Jacob Thomas, 7, leads little brother, Luke, 5, to the bus stop on the first day of school. Photo by their father, Larry Thomas of Green Cove Springs, Fla.

84

Just Kickin' It: Shannon Blaney Keeler, 31, and her sisters — Becky Blaney, 38, and Carol Blaney, 37 — have fun at their annual family get-together. Photo by Walter Blaney of Kingwood, Tex.

"Ready...BLOW!" One summer afternoon with the Wallace family—Christie, 38, Robert, 39, Kipp, 8, and Alexandra, 11. Photo by Christie Chew-Wallace of Villa Park, Ill., who used a self-timer on her camera so she could join in.

"I Wanna Be..." At the Early Childhood Center in Hempstead, N.Y., the children are encouraged to dress up and act out family-life situations. Here, Ma'at Enilo, 4, Eric De Vore, 5, and Diane Joseph, 5, get a glimpse of how it feels to be a grown-up. Photo by their teacher, Cori Wrobel of Garden City, N.Y.

*Flight of Fancy: Jordan Torres, 20 months, soars with the toy helicopter piloted by his dad, Peter.
Photo by Jordan's mother, Maria A. Torres of Brentwood, N.Y.*

For Men Only: Travis Prowell, 20, and his son, Phaedrus Raznikov, 8 months, at Gerstle Park in San Rafael, Calif. Photo by Alice G. Patterson of San Anselmo, Calif.

Endless Love: Ethel and Ed Phinney — married for 69 years — in front of their summer home in Maine. Photo by Judith A. McCaffrey of North Billerica, Mass.

Still in Time: Doris and Charlie Porter of Ithaca, N.Y., both retired, enjoy the fun of being partners. Photo by Donald Elliott of Albany, N.Y.

She Could Have Danced All Night: And, for three hours straight, she did! Rose Thier, 80, of Ash Flat, Ark., takes a twirl with her grandson, Chuck Thier, 28. Photo by Catherine Schuh of Wheaton, Ill.

Masters All: The Fazzolari brothers, Carlo, Joe, Nick and Tony (l-r), are members of the Portland Masters, a softball team whose players are all 60 or older. Photo by Judy Fralia of Portland, Ore.

Band of Cousins: At a family gathering, Stephen Pelucca helps his cousin, Jeffrey, 7, with a few notes. Photo by Stephen's sister, Victoria Jordan of Stockton, Calif.

Plucky: Bill Lipp of Bismarck, N.D., serenades his first granddaughter, Taylor Elizabeth Lipp, 6 months, who wants to get in on the act. Photo by Taylor's father, David Lipp of Mendota, Minn.

"I Remember...": Laurel Cazin, 39, of St. Paul, Minn., gathered memorabilia from her childhood and family photos to compose this self portrait. She sits at the piano she played as a girl.

Two of a Kind: Jonathan Svetic and his 4-month-old daughter, Sally, with Lake Michigan in the background. Photo by Sally's mother, Kelly Svetic of Milwaukee, Wis.

Home From School: Judith Taggart, 35, greets her niece Jamie Serat, 14. Photo by Sheri C. Neville of Orange, Calif.

What Makes Christmas: Lucille G. Tibbs and her granddaughter, Brianna Williams, 16. Photo by Oscar C. Williams of Kirkland, Wash.

Comfy: Keane Carlson, 1, enjoys a loving perch on the shoulder of his big brother, Jim Carlson, 25. Photo by their mother, Christine Carlson of Nickerson, Minn.

She's a Big Fan: Betty Day with her grandson, Doug Puryear, a football player at Indiana State University. "My grandmother drove 800 miles round-trip for every home game for the four years my brother played," said the photographer—Doug's sister, Terri Puryear of Coraopolis, Pa.

Here's Looking at You, Kid! Herman Hessemer, 90, of Tempe, Ariz., and Nicole Harbert, 3, relax together after a big Easter dinner. Photo by Nicole's grandmother, Floretta Price of Scottsdale, Ariz.

"Oh, You Beautiful Doll!" Rose Wilson holds her granddaughter, Chelsea, 4, as Chelsea holds her doll. Photo by Alicia Taylor of Miami, Fla.

"But You're Not Losing an Aunt!" LaJuanna Dean-Jackson, 29, tries to persuade her nephew, Terrance Dean, 10, that he's gaining an uncle. Photo by Darlene Morris of Chicago, Ill.

Lift of a Lifetime: Cheerleaders Sherry and Todd Watson of Columbia, S.C., on their wedding day. The couple call this photo — taken by Michael Davis of Bristol, Tenn. — "Three Cheers for Marriage."

108

"Let Me Show You How": Aaron Haan, 18 months, helps his grandfather, Alan Baugh, 65, fix a heel at Baugh's Shoe Store in Wayland, Mich., which has been in the family for three generations. Photo by Aaron's mother, Cheryl Haan of Grand Rapids, Mich.

*Big Push, Little Push: Charlie Offenbacher, 2, helps his dad, Curt, with yard work.
Photo by Charlie's mother, Ginny Offenbacher of Springfield, Ore.*

Jenna Pops One: Richard Virgo and his daughter, Jenna, 8. Photo by Jenna's mother, Dorna Virgo of Bettendorf, Iowa.

Helping Hands: Ruth Shaye, 87, of Alpine, N.J., gets a touch-up from her daughter, Zina Kushner, before a family party. Photo by Ruth's granddaughter, Jennifer Kushner of New York City.

Two Generations: Edith Ng Welsh, 41, and her grandmother, Look Sue Chan, 91, on the back porch of Chan's home. Photo by Edith's husband, Robert Welsh of Alameda, Calif.

Bunnies, Baskets, Breakfast and...: On Easter Sunday morning in Naples, Fla., Amber Pinson, 7, takes time out for some TV. Photo by Lee Ann Ropes of Winter Park, Fla.

On Her Own: Elana Goldman, 21, and her son, Quenton Goldman, 1, in their rented room. Photo by Diana Zora Leskovac of Silver Spring, MD.

118

Are They All Coming to Dinner? A typical Christmas scene at Joseph and Jane Serio's home in West Hempstead, N.Y. Mom's and Dad's stockings are surrounded by those of their 12 children and 10 grandchildren. Photo by son Stephen J. Serio of Evanston, Ill.

Sharing Grief: The family of Irene Hurley on the day of her funeral at St. Agnes Cemetery in Menands, N.Y. Photo by her grandson, Michael Bach of Albany, N.Y.

Remembering Dad: Katherine Mary Reid of Pittsburgh, Pa., kneels to kiss the gravestone of her father, Bernard Meredith Reid, a veteran of World Wars I and II. Salvador A. Portugal of Pittsburgh, captured the moment on Memorial Day 1994.

The day fades, but Anna Gorciak, 4, finds that there's still time for a sunshower at her grandparents' home in Cottonwood, Idaho. Photo by her uncle, Stewart Harvey of Portland, Ore.

First Trip to the Ocean: The Constantini children—Michael, 9, Brian, 7, Kelly and Melissa, both 4 (l-r), on the beach at Wildwood Crest, N.J. Photo by their mother, Terry S. Constantini of Steubenville, Ohio.

"Go Soak Uncle Mike!" That's just what Dani Brunelle, 9, does as her cousin, Heather Peterson of East Sandwich, Mass., snaps the picture. (For his part, Uncle Mike McTygue, a practiced father of three, didn't look up till he reached the end of the paragraph.)

A Moment of Truth? Brian Mansfield, 5, and his brother, Steven, 3, are best buddies. But they love to tease each other—as they did this day on the beach, says their mother, Deborah R. Mansfield of Houston, Tex., who took the photo.

Olivia Simons, 1, looks up to her big sister, Samantha, 5. Photo by their mother, Carole Simons of Lancaster, Pa., who says that, with family love, physical handicaps aren't barriers.

Family of Three: Barbara Stoltzfus, 23, her son, Derek, 2, and her daughter, Lauryn, 1, take their regular Sunday stroll in Cochranville, Pa. Photo by Barbara's father, Robert Derr of York, Pa.

Stephen's First Haircut: Stephen Ruisi, 1, gets ready for hairstylist Jaci Gallo as his brother, Joseph, 4, helps out. Stephen's mother, Jean Ruisi, has the easy job. Photo by the boys' father, Nino Ruisi of Miller Place, N.Y.

"It's a family affair."
—Sly and the Family Stone

"The child is father of the man."
—William Wordsworth

"Honor thy father and thy mother."
—Exodus

*"You belong to that Brotherhood of Man!
That great, big Brotherhood of Man."*
—How to Succeed in Business
without Really Trying

Inseparable: Sarah Lynne Scharke and her twin sister, Megan Nicole, 21 months, enjoy being together in a field of tulips. Photo by Lynne Zoyiopoulos of Greeley, Colo.

Soon They'll Muscle Into the Majors: Tanner Daniel, David Muscatello and Ryan Keaton (l-r), all 8, are Little League teammates in Southlake, Tex. Photo by Tanner's mother, Debbie Daniel of Southlake.

Prima Ballerina: Robert "Shelby" Ruddick of Glen Allen, Va., and his granddaughter, Caron Elizabeth Sinnenberg, 4, after her dance recital. Photo by Caron's mother, Beth Ruddick Sinnenberg of Richmond, Va.

Cards and Flowers for Granny: Erin O'Brien, 3, and her sister, Kelly, 5, present their grandmother, Antoinette O'Brien of Warren, R.I., with tokens of affection. Photo by the girls' mother, Cheryl Muller O'Brien of Englewood, Colo.

Tradition: When the sun rises and sets, Hector Crepeau, 82, tends to the American flag in his backyard. On this day, his granddaughter, Erin Crepeau, 4, got to help. Photo by Erin's father, Donald Crepeau of Swartz Creek, Mich.

Circle of Love: David and Carole Simons with their daughters (l-r), Olivia, just born, Natalie, 2, and Samantha, 5. Photo by Edwin P. Huddle of Lancaster, Pa.

REFLECTIONS OF THE CONTEST JUDGES

The American Family lives in everybodys' wallet and especially in the wallets of America's grandmothers. I fly all over the world and invariably I enjoy the company of a woman sitting next to me whose family resides in her wallet in the form of a photograph. Through the photograph I get the opportunity to meet her children and grandchildren, learn their names, their whereabouts, whose side of the family they take after, and an anecdote or two.

The portrait of the American Family has changed. I have a black-and-white photograph on my wall at home of my mother at the age of sixteen in her sister's wedding party. The family is big, the clothes are very formal, and the faces are very still and serious, patiently waiting for the photographer to make one frame with a cumbersome wooden 8 x 10 camera. I compare it to the spontaneous photograph of my family at Christmas captured at 1/125th of a second with a Nikon point-and-shoot 35mm camera. People are caught in mid-gesture, laughing, eating and fully animated. I look back at the old portrait full of stiff figures and realize that five minutes before this family was captured on film in 1926 that they were probably laughing and eating and vibrant and loving. They just had to hold still for slow speed film as opposed to Eastman Kodak's high speed film of today. It makes me realize that the love in the American Family has not changed--just the times we live in. And we live in fast times with our families spread all across America—not just down the street, across town, or in a neighboring city. To make up for this distance, the American Family has learned to share special moments with their far-flung relatives through photographs.

The pictures you see in this book are photographs that people took of their family for their families. I'm sure many of these photos were slipped into a holiday greeting card to share with family living far away. And what better way is there to keep in touch and share your love?

I am also a grandpa and just don't see my granddaughter Danielle too often. When I do see her I make sure I take a photograph of her. And if you're sitting next to me on a plane, with very little coaxing, I'll show it to you.

Eddie Adams

Like everything in life, we can look at these photographs in many ways. We can and should appreciate them for their artistry, their pure visual joy. But beneath that pleasure is something even greater—call it thought, call it soul, or better yet, call it humanity.

What makes a family has been, lately, the subject of divisive arguments. But what I see in these pictures—and the thousands of others I saw as a judge—are things that bring us together. Some photographs show genetic bonds, a kind of physical continuity that snakes back in time. For example, a mother gazes at her newborn baby, a grown daughter gives her mother a lipstick touch-up. But there is more. What about the classmates, the teammates and the playmates that are so abundant here? They are all visions of "family." We begin to think that there is more to do with family than blood or arbitrary definitions. It seems to me that it is as much a bond of caring, of the many forms of shared experience.

We share milestones like birthdays and holidays, and activities like playing with fall leaves or eating meals. This is how we truly learn to give of ourselves—our ideas and our emotions—and to accept what others can offer us. Without this, each of us would be an island. With it, in a sense, our family is global.

Dr. Joyce Brothers

A nation that values children cherishes its families. This is certainly the time to celebrate families, as America's families struggle to confront many of the same old challenges of rearing children—plus a number of new ones.

In families each generation is nurtured, taught, protected and guided morally. The strength of families is what ultimately determines the viability of our future. If we as a nation do not build up families, or choose to undermine families' abilities to respond to their children's needs, we cannot expect to leave the world a better place for our sons and daughters.

Too much attention lately has been focused on what's wrong with families. The American Family Photo Contest rightly turns the spotlight on the enduring, unstoppable bond of family life that is an inseparable part of human nature.

I hope that these photographs—a little girl in a floppy straw hat having tea with her "friends," an older brother holding his younger brother's hand while walking to school, children with their grandparents playing outdoors—will help lead us to a sense of family that embraces and holds us responsible not only for our own children but for all children. I hope that the images—a youngster sucking her thumb, families in worship—remind us that all children need our protection and commitment. I hope that the emotions you see in this book—joy, tears, pain, strength, love—persuade each of us that we are part of a larger family that includes different colors, creeds, languages and ideologies.

We are all family, bound together to form a loving and protective shield for our children.

Marian Wright Edelman

Michael Eisner

As I looked at the images, some of which were funny and candid while others were more formal or touching or eloquent in their simplicity, I was struck by what was common to all. Each photo, in its special way, showed how important it is for us to connect with others. As a newborn, a centenarian or somewhere in between, whether with kin, friends, neighbors or teammates, we all need the comfort, support and care that these connections provide. With this strength we can each go forward to lead productive, meaningful lives.

Carol H. Rasco

When I was asked to participate as a judge in the American Family contest I thought, "What a great idea!" because this is what our country is all about.

As a mother of two children and as the Assistant to the President for Domestic Policy where I work on issues such as welfare reform and child care policy, I see families as the most important unit of our society. My 14-year-old daughter, Mary-Margaret, and my 21-year-old son, Hamp, who is mentally and physically disabled, are very special to me. In nurturing them, I feel that I am also nurturing the future.

Of course, families mean different things to different people. Take for example, the photograph of Wendy and John Garvey and their three adopted children. Or the picture of two elderly neighbors who have taken care of each other for years especially since one of them is blind. But perhaps for me, nothing provides a better visual definition of the word family than a picture of several generations, as in the photo where Chris Bordelon holds her just-born granddaughter and her daughter looks on proudly.

As I looked through these pictures, I believe that I probably experienced the same emotions that these children and adults must have felt when they took them. But that's not to say you have to be a parent to enjoy these visual tales. These photographs will surely evoke poignant family memories of your own.